Teleri Lloyd-Jones

David Mellor

DESIGN

Antique Collectors' Club

Design Series format by Brian Webb
Text © Teleri Lloyd-Jones
Foreword © 2009 Terence Conran

ISBN 978-1-85149-603-7

British Library cataloguing-in-Publication Data
A catalogue record for this book is available from the British Library.

www.antiquecollectorsclub.com

Antique Collectors' Club
Sandy Lane, Old Martlesham,
Woodbridge, Suffolk IP12 4SD, UK
Tel: 01394 389950 Fax: 01394 389999
Email: info@antique-acc.com
or
ACC Distribution,
6 West 18th Street,
4th Floor,
New York, NY 10011, USA
Tel: 212 645 1111 Fax: 212 989 3205
Email: sales@antiquecc.com

Photography:
© Michaels Boys, 52 (bottom). © Peter Cook, 80. © A. Court, 38. © Design Council,
31,39, 42 (top), 48 (top), 49, 50-51. © Clareville Studios, 34 (bottom), 40, 44, 49
(top and left), 51, 55, 56, 61 (top), 63, 67, 68, 84 (left). © John Garner, 5, 85. ©
Turner Gee, 54. © Derek Greaves, 78-79. © Peter Hill, 34 (left), 73, 75, 77, 81, 84,
85, 88, 90. © Corin Mellor, 27 (top). © Helen Mellor, frontispiece, 16, 27 (bottom),
29, 30, 33, 34 (top), 36, 42 (bottom), 43, 44 (top), 44, 46, 48 (bottom), 50, 57, 59,
60, 61, 62, 64, 65, 70, 72, 89. © Phil Sayer, 21 (bottom). © Henk Snoek, 52.
© Worshipful Company of Goldsmiths, 32, 40 (top), 45, 47.

The covers are reproduced from David Mellor's disposable polystyrene cutlery, 1969, and
endpapers Sheffield, 1930s.

Title page: top, Embassy silver toast rack, 1963. Bottom, toast rack for Walker & Hall,
silver plate, 1961. Page 3, and 96: Quentin Blake's illustrations from David Mellor's
Kitchen Guide. Page 6 Traffic lights for the Ministry of Transport.

Published by Antique Collectors' Club, Woodbridge, England
Design by Webb & Webb Design Limited, London
Printed and bound in England

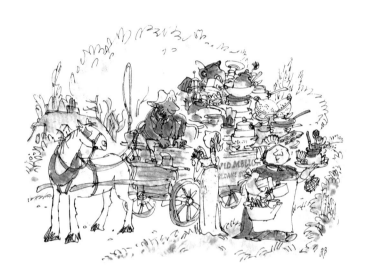

Foreword

David Mellor has always seemed to me to be the perfect design of a modern British Designer.

He believed in Plain, Simple and Useful modernity — practicality came high on his agenda and he always wanted to know how something was made before he designed it. He enjoyed the process of manufacture and practised it superbly well. He wanted to follow his products to the eventual purchasers' own homes so he opened several excellent shops — he controlled the entire chain, from brain to kitchen worktop.

Although sensibly ambitious and entrepreneurial he rejected gimmickry in his design and presentation; you wanted his products because they were useful and beautiful, they were not bought as decorative items to make your kitchen look trendy or fashionable.

I have always found that I could understand him quite well as I am almost exactly one year younger than he was and therefore had been through the many ups and downs of the war and post-war years which have had quite a significant effect on the practicality and economy of our work — very different from, say, Philippe Starck or Karim Rashid.

I am very lucky to both live and work in a fine building in Butler's Wharf near Tower Bridge, which David commissioned from Michael Hopkins, his architect, but which was practically built by David and his son who were on site every day. You can feel his intellect in the design and planning of the building and the execution of the details, practical and thoughtful and high quality as always in everything he did. After you have read this book, I hope you might agree with me if I nominate him as Britain's most serious, modest and greatest post-war product designer. Long may his influence be felt in design education and the work of British designers.

Terence Conran

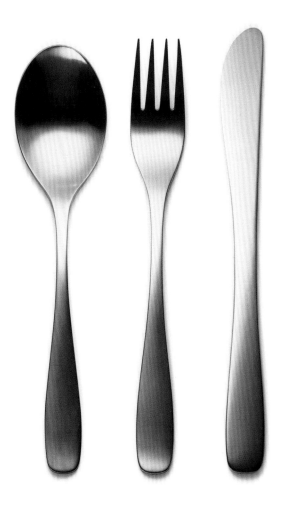

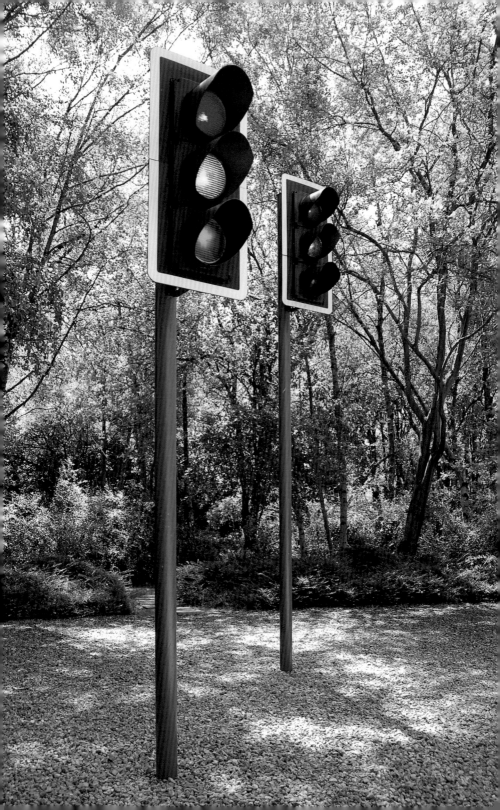

Design
David Mellor

'If you are in it for the long run,' Hugh Pearman warned in 1995, 'it is best to avoid, as Mellor has, cult status. Cults are short-lived: good knives, forks and spoons are immortal.'[1] And so Pearman, along with countless other critics, heralds Mellor's cutlery as classic, iconic. Yet to see Mellor as 'just' a cutlery designer is to miss his depth: his love of public projects, street furniture or Church commissions. But then to see Mellor as 'just' a designer is to miss his influence as a patron of architecture, or his passion for retailing and promoting British crafts. He may be the 'King of cutlery' but that is just the beginning.

Mellor's achievements are always framed by the city he grew up in, Sheffield. Being the centre of cutlery production in Britain since the seventeenth century, the city grew and thrived throughout the Industrial Revolution. It stood at the vanguard of British metalworking including the homegrown inventions of silver-plating and stainless steel. During Mellor's childhood the 'city of steel' still held its status as a centre of manufacturing, and the surroundings reflected the proceeds of such business. As a designer, his practice never strayed too far from his home city. Born 5 October, 1930, Mellor grew up in a terraced house in the west end of Sheffield. His father, Colin Mellor, was a tradesman who made tools for the Sheffield Twist Drill Company. David Mellor's upbringing was full of 'making'; his father built him toys and when the young boy suffered with chicken pox his father painted a tulip panorama on his bedroom door. The household was a creative incubator and his father encouraged Mellor to develop his talents.

Along with his sister Margaret, he attended the local Lydgate Lane School. When Lydgate Lane School was requisitioned during the war he moved to Crookes Endowed School. He was not a natural scholar, and put his energies into designing and making. During

Warship Week in the early 1940s, he won a prize for his model ship, presented by Sir Ashley Ward, the chairman of Thomas W. Ward, a famous firm of ship breakers. This led to his first paid employment: to make models of ships the firm had broken up, he received £3.15s for each model. He made about twenty model ships in all, delivering them to Sir Ashley who kept them in mahogany showcases; even as a boy Mellor's talent was being rewarded and admired. Just before his twelfth birthday, he found more contentment when he left traditional schooling for the Junior Art Department of Sheffield College of Art (SCA). Moving to the college in 1945, he was immersed in the Arts and Crafts morality of making and the importance of craftsmanship. The curriculum included metalwork, pottery, house-painting and decorating; he also attended life classes. Mellor discovered a skill for 'graining', painting on surfaces to imitate wood or marble – this is rather ironic considering his later dedication to the beauty of material honesty. The college had begun in 1843 and was rooted in the teachings of the Arts and Crafts movement and therefore had a strong crafts bias. Mellor was taught by William E. Bennett, who in turn had been taught by Omar Ramsden, the Arts and Crafts silversmith who had trained at the Sheffield School of Art in the 1890s; a prestigious lineage of domestic talent. For Mellor, this education was a sort of salvation, he later said that without it he'd have been a disaster.

Mellor's work from these early years is interesting, both expressing a visual restlessness and the kernel of his future style. His earliest piece of metalwork is a sweet dish made when he was only eleven years old, with a twist decoration on the rim and the handles it still maintains the restraint of the Mellor style. During his time at the Sheffield College of Art, Mellor made two silver spoons, which although extenuated and exaggerated in form show the beginnings of his future cutlery design *Pride*. An oak sideboard with steam-bent rosewood handles, made by him in 1947, betrays a dalliance with contemporary style holding one foot in the Arts & Crafts movement whilst the other faces eagerly towards Modernism. Developing an

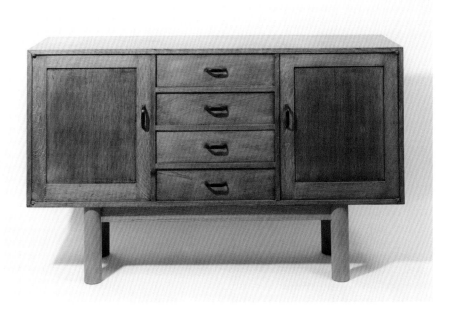

Oak sideboard with steamed and bent rosewood handles
and green painted interior, 1947.

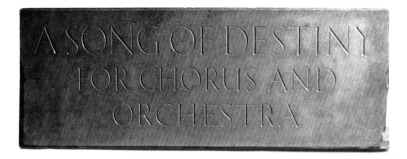

Letter cutting exercise, *A Song of Destiny*, slate. Both pieces
made during Mellor's time at Sheffield College of Art where
his training ranged from house-painting to life drawing.

interest in modern design, Mellor took his first trip to London in
the winter of 1946 to see the 'Britain Can Make It' exhibition at the
Victoria & Albert Museum. A seminal exhibition, it celebrated the
return to peacetime and production, and was organised by the newly
created Council of Industrial Design. After years of bomb damage,
coupons and utility goods, the British audience craved novelty,
modernity and above all, hopefulness. Mellor and his friend, Harold
Bartram, made a pilgrimage to the exhibition, missed the last train
home and spent the night sleeping on deck chairs in Green Park.

Between 1948 and 1950 National Service interrupted Mellor's
formal education as he entered the 8th Tank Regiment at Catterick,
North Yorkshire. Spending eighteen months in the army was
awkward for Mellor, who was not a naturally militaristic man.
He had recently discovered the work and writing of Eric Gill,
specifically his essay *Art Nonsense* first published two decades earlier,
and managed to locate himself in the signwriting department, a
small creative branch within the barracks. Under his own steam,
Mellor changed the entire camp's signage, including that of the
tanks, to 'Gill Sans' type. Still a relatively contemporary design,
it had recently been taken up by the newly nationalised British
Railways in 1948. His future tutors at the Royal College of Art,
Robin Darwin and Robert Goodden had worked on camouflage
during wartime, and Mellor's endeavours at Catterick act as a neat
contextual stepping stone from then pointing forwards to the
world of brand management that emerged in the 1960s.

After this hiatus in his studies, Mellor arrived in London in 1950
to enrol at the Royal College of Art (RCA). The late 1940s had seen
Robin Darwin's reform of the RCA. Darwin, the rector, was not
only pioneering a new role for his students to take in the modern
world but the college was also swept up in preparations for the
Festival of Britain the following year. Mellor was the perfect age
to take advantage of these opportunities and he had been hand
picked by Darwin to attend, along with fellow SCA student Derek
Greaves. Harold Bartram and Brian Asquith in the year below

DM

Mellor at the SCA followed the same route. Darwin's changes at the college revolved around the reconciliation between art and industry, to combine 'the sensitivity of artists, the technical know-how of production engineers and amused and well-tempered minds' – a challenge that Mellor doubted was achieved in his time.[2] Darwin, and later Mellor himself, was inspired by the production models from Scandinavia. Designers like Kaj Franck and Arne Jacobsen successfully worked within various industries and with various manufacturers whilst maintaining an artistic pedigree. This intertwining of industry and creativity was something that Britain lacked, or as one writer in the sixties put it: 'pupils mapped out their futures in wholesome artist-craftsman studios, not in squalid industry. Conversely, and quite naturally, factory managers tended to find art school people impractical and over-opinionated.'[3]

The college provided extra-curricula opportunities for Mellor, notably the chance to travel abroad. In 1952 he was awarded a summer scholarship to Sweden and Denmark, countries that impressed him with their public design aesthetic particularly the use of modern metals like aluminium or stainless steel. The following year Darwin chose Mellor, along with fellow student Geoffrey Baxter, to attend the British School at Rome. Other students in attendance included Michael Andrews, Euan Uglow, and Derek Greaves (Mellor's Sheffield contemporary). The standard of quality retail outlets in both Scandinavia and Italy impressed the young Mellor and he regretted the lack of such establishments in Britain.

But the momentum of British design was boosted radically by the advent of the Festival of Britain. As London's South Bank was reconfigured with the Royal Festival Hall, the Dome of Discovery and the 300-foot Skylon, over 8 million people visited to see the displays and projects by a wide range of artists and designers, such as Eduardo Paolozzi, Jacqueline Groag, Ernest Race, Henry Moore, Robin and Lucienne Day. The success of the Festival undoubtedly cemented the position of the Council of Industrial Design within Britain. The new generation of RCA tutors, Hugh Casson in

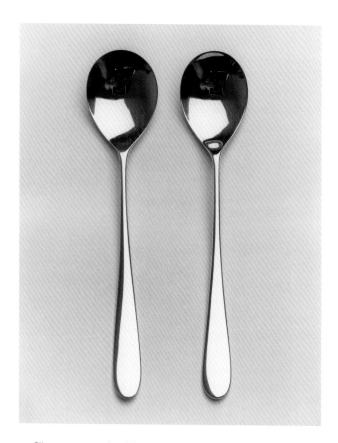

Silver spoons made while a student at Sheffield College of Art.
Their lack of embellishment and decoration reflected Mellor's
interest in the modern style, their shapes anticipate the elegant
simplicity of his later famous design *Pride*.

particular, along with Dick Russell, Robert Goodden and Richard Guyatt, were heavily involved in the Festival and setting the style for Britain in the 1950s. It is difficult to exaggerate the optimism of the design world and the RCA during the early fifties. Mellor himself remembered it as 'a period of great excitement. You felt as if you were putting the world together again'.[4]

An interest in cutlery had followed Mellor from his home city, and at the RCA he realised one of his most famous designs. Drawing on his concept for the spoons he had made earlier in Sheffield, he devised a set of silver-plated cutlery which he called *Pride*. There is a commanding simplicity to the *Pride* design; though showing no trace of self-consciousness, these pieces are elegant beyond credulity. Still in production over half a century later, it is easy to call them a 'design classic' but somehow that phrase fails to do them justice. Peter Inchbald was a student at the RCA at this time, eager for products to help modernise his family firm Walker & Hall. He approached Mellor about his *Pride* cutlery, sparking the beginning of a strong working relationship between the designer and company. In 1957 *Pride* won one of the first series of Design Centre Awards. Decades later, during the annual introductory lecture to freshers, Christopher Frayling (RCA Rector 1996-2009) cited the *Pride* set, declaring that Mellor was the first to produce a lasting design whilst still a student at the college. Mellor's RCA thesis was entitled 'The Development of the Cutlery Industry' and demonstrated his respect for the history of the trade, but it also gave a wonderful grounding from which to experiment and break the rules of a tradition. Although his designs respect traditional forms, his work always appears modern. Describing himself as an 'instinctive modernist', his designs rely on honesty of form and material – honesty used not as a synonym for dull, but a reflection on a quiet elegance that refuses to hide behind embellishment.

Along with others in his generation – Gerald Benney and Robert Welch in particular – Mellor was one of the new designer-consultants to come out of the RCA. The career was one of

multiplicity and adaptability, similar to the Scandinavian model he admired; it was something that Mellor relished. Within the first years of his graduation he was designing cutlery, street furniture, altar silver and typewriters. Inspired by his travels abroad, Mellor wanted to develop new street lighting for Britain, proposing a modern design in tubular steel. He made a series of models, whilst still at the RCA, and went searching for a backer. The North Midlands Engineering Company Ltd, which later became Abacus, took on the project and the first tubular steel lights began appearing on British roads. His relationship with Abacus continued and Mellor went on to design Britain's first modern bus shelters in 1959; an estimated 140,000 were installed around the country. The shelters were made from galvanised steel with large sections of glazing, and were designed with a conscious effort to discourage vandalism. Mellor's work with Abacus was productive and led to other designs for bus shelters, bins, benches and seating: each strikingly simple and undeniably modern.

Throughout the first decades of his career Mellor continued to complete individual commissions for both Church and civic metalwork. These projects display a more varied approach, especially towards decoration, than can be seen in his mass-produced design. The altar silver, such as the nave altar cross and candlesticks for Southwell Minster, show his modern geometric style but also an interest in surfaces. An eighteen-light silver candelabrum made for the City of Sheffield, in 1960, showed a modernist's love of straight lines and right angles resulting in a disorientation of flame and reflection. A series of silver boxes Mellor produced in 1966 for the Worshipful Company of Goldsmiths are given textured gilt lids, still based on a geometric grid but coming closer to an architectural rendering. One of Mellor's most interesting commissions was a collaboration with the sculptor Elisabeth Frink to produce a crucifix and candlesticks for the Lady Chapel of the recently completed and architecturally radical Roman Catholic Metropolitan Cathedral in Liverpool. The considered balance of Mellor's design fused to Frink's Expressionist figure of Christ on the cross makes an

interesting contrast, each aesthetic approach giving what, perhaps, the other had lacked. One of the most striking pieces Mellor created was, quite appropriately, a large silver bowl for the Company of Cutlers to celebrate the 200th anniversary of the Sheffield Assay Office. This large bowl, 45cm across, was constructed from 201 identical segments radiating from its centre. Each segment was engraved with a year date, and, on coronation years, the name of the new monarch. From a simple concept Mellor created an astoundingly beautiful object. Uniting all these commissions is the importance of the material: Mellor's approach always celebrated the beauty of metal. It was the love of his life and no matter what type of object, mass-produced or unique, a candlestick or a rubbish bin, he took care to express the elegance inherent in the material.

Mellor's process was centred on the physical object, tinkering with and altering the prototypes through countless stages. Drawing was never a large part of his practice; employed in the workshop, his assistant, David Higham, provided most of the working drawings for the designs. Mellor obviously thought through problems using the objects. The intelligence of the hand was so central to Mellor's working; even though many of his designs ended life in mass-production borne out of his craft. It seemed logical to design such objects from the perspective of the hand, especially if, like the cutlery, they were to be tactile objects. Even in later years, as computers became more integrated into the design process, Mellor remained wedded to his traditional practice of making and modifying. Many of the cutlery dies for the David Mellor factory are still made by hand ensuring the same perfection in detailing.

In a city that was seduced, transformed and trampled by the post-war modernist vision, Mellor quietly carved his own architectural initials into the landscape. His building commissions in and around Sheffield, three in total, in 1960, 1973 and 1990, connected living quarters, offices and workshops into one site as an expression of his working philosophy. Patrick Guest designed the first house that Mellor commissioned. This new building at No. 1 Park

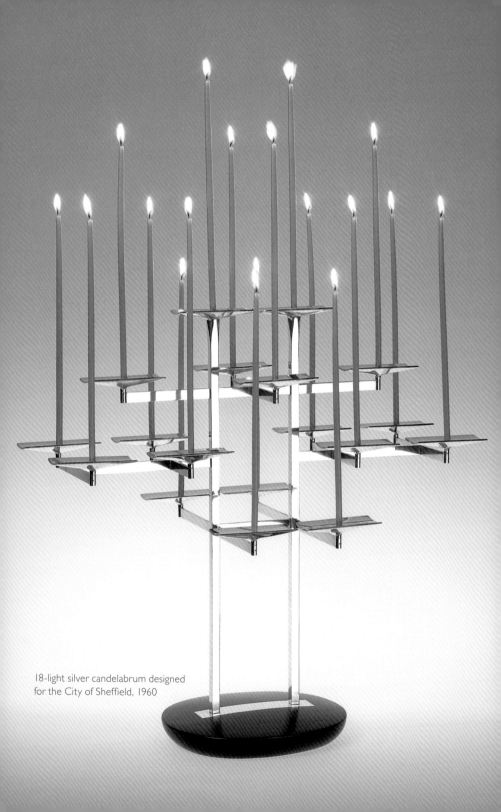

18-light silver candelabrum designed
for the City of Sheffield, 1960

Lane, in a western suburb of Sheffield, which was described by
contemporary commentators simultaneously as, 'a superb piece of
modern thinking', 'an unpretentious and well-detailed oblong box
of bricks and glass', and, 'modern, almost shockingly so'.[5] It was
an elegant single storey modernist design with large expanses of
glazing. Mellor decorated it with the appropriate accoutrements of
a successful modern designer: Eames chairs, a Kaare Klint light and
work by the abstract artist Pierre Soulages. His commitment to work
was expressed by the ability to walk directly from his living space
into the design studio and then the workroom; it was compounded
by the lack of a bedroom (instead the bed was hidden inside a
drawer). Mellor's work was such an integral part of his life and his
enjoyment that there was never any artificial divide between the
spaces for living and the spaces for working.

Mellor was gaining a reputation for his elegant modern designs and
in 1963 was approached by the Ministry of Public Works who had
embarked on a policy of modernizing the tableware used in British
embassies around the globe. This was a very large and prestigious
commission that involved Mellor's former RCA tutor, Robert
Goodden, designing the glassware, and Richard Guyatt designing
decoration for the Minton ceramics. They had a difficult task:
expressing a confident, forward thinking Britain whilst avoiding
radicalism or pretentiousness. Mellor's *Embassy* design was elegant
and tapered in form, made in sterling silver – the only particular
unorthodoxy being the three-pronged forks. It won Mellor his
fourth Design Centre Award. The *Embassy* cutlery was manufactured
by Sheffield forgers C W Fletcher, whilst Mellor's own workshop at
Park Lane produced the condiment sets, pepper mills, coffee pots,
tea kettles, candlesticks and other tableware items. Pleased with the
results, two years later, the Ministry commissioned a basic set of
cutlery to be used throughout government canteens in hospitals,
schools, railways and prisons. Replacing the repressively traditional
Old English cutlery, Mellor's *Thrift* design reduced the number
of pieces from eleven to five. This lowered the manufacturing
and maintenance costs considerably, but it was also symbolic

of the wider changes in the sixties. Mellor was rationalising, revolutionising even, the social function of cutlery, and some local Sheffield traditionalists were reeling from the loss of the fish knife: 'The Americans may not be able to tell a fish knife from a butter knife but in Britain according to the basic principles of Sheffield cutlery manufactures, there is a "tool for every job".'[6] There may have been some reactionary outcry in Mellor's native city, but the design was a success in other quarters and won Mellor his fifth Design Centre Award. In fact, he became such a regular on the award's lists that one year a journalist noted the prizes went 'not all to the same winners of course. This time, David Mellor has designed only three of the winning pieces.'[7]

In 1964, the designer was interviewed by *Guardian* journalist, Fiona MacCarthy for a weekly column on British crafts. With his usual deadpan humour, Mellor recalled their meeting, 'I remember taking her to a steak house in Sheffield which was just as modern as you could get in Sheffield at that time. She then asked me out to lunch. In London. Which I thought was *very modern*.'[8] He also remembered the 'inevitable' blunt knife he was given to eat his steak with. They married in 1966 and their son, Corin, was born that year; their daughter Clare arrived in 1970. MacCarthy went on to win accolades and prizes as the author of various biographies on central creative figures like Eric Gill and William Morris. MacCarthy's talents for writing, curating and promotion twinned with her knowledge of design history undoubtedly enhanced Mellor's own ventures. To some extent, it is difficult to define Mellor's success without considering the importance of MacCarthy's support and, as a couple, their contributions to the landscape of late twentieth century British design were profound and wide-reaching. MacCarthy's input was often anonymous; however most writings from within the business – perhaps even those with Mellor's name attached – have felt the influence of her hand.

Although the cutlery business heavily defined Mellor's position in design, one of his most high-profile projects was the modernising

redesign of the British letterbox. Although small design changes
had occurred throughout the years, the pillar box had not altered
in any major way since 1879. But the sixties saw a move to
comprehensively remake the Post Office with a brand identity
for modern times. In 1966, Mellor's design centred around the
postman's experience: it made the collection more time-efficient
and physically easier. This step forward in efficiency went hand in
hand with a radical change in aesthetics as the Victorian Trollope
shape, with its regal finial, became a simple, slender oblong form,
whilst retaining its defining shade of red. Mellor's initial design
used vitreous enamelled steel for economic reasons. However, to
Mellor's disappointment, the boxes were finally made cast-iron – a
concession to tradition perhaps? Unveiled in Paternoster Square in
London, the prototype was collected from the square a couple of
days later when it was discovered full of mail. The Trollope post-
box had, by then, become a symbol of Britishness, a Britain which
Mellor, and many others, were eager to coax into the modern world,
and this was his most publicly contentious design. Concerned letters
were published in newspapers: 'How heartily sick we are of straight
lines and uniform angles!' M Rollason exclaims; 'A curve in a city is
a glorious thing' writes Anne Scott-James, 'What's the most beautiful
building in Rome? The circular Pantheon. What's the handsomest
street in Britain? The Royal Crescent in Bath. Which is our best
designed shop? Peter Jones, which is built on a curve, What's the
nicest sort of window? A bow window. And the best sort of letterbox
is rich, fat, comfortable and round.'[9] These rigid attitudes must have
disappointed and unnerved the designer, who later commented,
'We are a nation of nostalgics. We had this brief period in the fifties
when modern design was the thing to have but now we're back
where we were in the thirties'.[10] The straight edge of modernity
doing battle with the curve of tradition; one writer lamented, 'I
suppose we must start moving with the times, but still I mourn.'[11]

Arguably, Mellor's next public furniture project was quieter but led
a more pervasive change throughout the British landscape. After
the Worboys Report of 1963, the redesign of the traffic system

was recommended to ensure safety on the streets. Along with Jock Kinneir and Margaret Calvert's overhaul of road signs, Mellor was commissioned to design the traffic lights for the national traffic system. His design, as was his style, held clarity and simplicity at its core, and like the post-box its purpose was to bring efficiency and modernity to the streets of Britain. Gradually, over 4,500 traffic light sets were replaced.

After marrying and starting a family in the late sixties, Mellor outgrew the severe modern living of Park Lane and began looking for a new house. This time he found a real challenge, buying a part-Georgian and part-Tudor mansion called Broom Hall, again in the green suburbs of Sheffield. Mellor and MacCarthy had watched the slow deterioration of the building with concern, and now they could set about bringing the site back to life. Its size allowed expansion for both the living and working quarters. Having trained numerous silversmiths – among them Grahame Rich, Russell Rimes, Simon Beer, Jack Spencer, and Ken Bradley – Mellor was making a conscious effort to develop into mass production. He was getting frustrated with the extenuated process of 'design by committee' which he had been subjected to with his involvement in the public sector and his consultancy work for large companies. He knew that the freedom and flexibility he craved would come from designing and manufacturing on his own account.

Mellor saw a gap in the cutlery market, as 'the cumbersome firms steeped in traditional design and methods, blinded by past glories [had] faded away'.[12] By the late sixties multiple mergers had caused many small, independent cutlers to be swallowed into larger corporations. However he always staunchly defended the importance of British manufacturing and publicly berated the influx of cheap imported cutlery from the East. By remaining in 'the city of steel', Mellor placed his business within the context of Sheffield tradition but also defined himself against it through some idiosyncratic production methods. Specifically, he avoided taking on cutlers with experience to ensure no friction from traditional

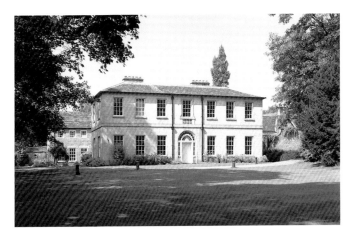

Broom Hall, the part-Tudor and part-Georgian mansion Mellor converted into a modern cutlery factory and home.

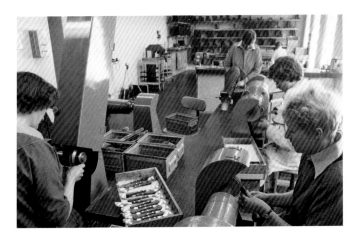

Provencal cutlery being made at Broom Hall. The project was a large commercial risk for Mellor but that was far outweighed by the freedom it gave, 'being on one's own is marvellous. Of course I work happily with big firms, but oh, the time wasted with committee decisions and the pleasure of being able to put all my energies into design and real work.'

methods. The usual division of labour used in the manufacturing process was sacrificed for a rotation system, which meant that each worker experienced every process – Mellor joked this saved one poor soul from polishing all day, every day. At Broom Hall there were modern machines but these were constantly adapted to fit specific manufacturing requirements, a pragmatic attitude that Mellor always had towards factory production. He was preoccupied by the possibilities of mass production; both his childhood in Sheffield and his education during Darwin's reign at the RCA had impressed upon him the vital importance of industry and design's symbiosis. As a young man he had read Gill's *Art Nonsense* which pithily declared 'It is no more unusual to make things by machinery than by hand. It is immoral to make things badly and pretend that they are good and no amount of 'hand' is an excuse for stupidity or inefficiency' – a sentiment with which I'm sure Mellor would have agreed. The Broom Hall workshops were modern and spacious, a total contrast to the larger cutlery factories on the other side of town, and, as at 1 Park Lane, they still led straight into the living quarters. Mellor's profits from his consultancy went into this business; he was adamant that this arrangement was commercially feasible and not a romantic ideal. The renovation took nine years – a definite trial, but in 1975 he won a European Architectural Heritage Award and the David Mellor business won an RSA Design Management Award six years later.

Having developed from designing to manufacturing, it was logical for Mellor to follow through to the final stage of the process and move into retail, thereby allowing him over-arching control over his designs from start to finish. Inspired by a cavernous – both in size and product line – shop he had visited in Helsinki, Mellor opened his first shop in 1969. 'David Mellor, Ironmonger' was a title that harked back to his origins in Sheffield. Based in Sloane Square, it was near the fashionable west London Sixties scene, which was home to boutiques of Mary Quant and Zandra Rhodes. The first Habitat on Fulham Road had opened five years previously and Elizabeth David's shop was a stone's throw away on Bourne

Street. Defining itself as 'the shop where you can get things which work and not just things which look good', David Mellor at Sloane Square sold a wide – perhaps too wide – range of products from nails and screws to handmade pottery by Richard Batterham.[13]

The shop was part of a zeitgeist in food that popularised European cuisine in Britain led by the success of Elizabeth David's post-war writing *Mediterranean Food* (1950), *Italian Food* (1954) and *French Provincial Cooking* (1960). Mellor's shop offered such brands as Waefa and Le Creuset which were continental icons for the fashionable kitchen. Mellor's cutlery design *Provencal*, first manufactured with rosewood handles in 1973 had a simple, rural aesthetic, and that, as well as its name, fitted seamlessly with this quasi-rustic and europhile lifestyle. Developing on the manufacturing techniques used for *Provencal*, the *Chinese Ivory* design was introduced in 1977. Combining resin and stainless steel (the first cutlery design to do so) its aesthetic was clean and crisp; the handles sat flush with the tangs giving each piece a silhouette of parallel lines. *Chinese Ivory* won a Design Centre Award and became a defining design of its time. Mellor considered the art of shopkeeping undervalued and enjoyed the challenge of display, he saw this part of the business as an extension of his role as designer, referring to the notion of choice – that design and retail were all concerned with the choice of how we want to live. It may be surprising to hear how important these shops were to Mellor. He liked the sense of theatre and close connection between production and audience the shop allowed – he once confessed 'I don't like being a public figure… but I do like standing in the street looking at the shop.'[14] It attracted the great, the good and sometimes the famous but Mellor greeted everyone the same, perhaps out of principle but more likely his genuine inability to recognise celebrities (the pinnacle of which occurred when he failed to realise he was serving Jackie Onassis).

Each product was scrutinised and tested before entering the shop's canon and this fact was emphasised in every catalogue.

Quentin Blake, a contemporary at the RCA, illustrated
several of the *David Mellor Kitchen Guides*, repeating the
same couple on the illustrations throughout. Large Blake
illustrations also decorated the Sloane Square shop.

The catalogues, and indeed the shop, were embellished with
illustrations by Quentin Blake, a contemporary and friend from
the RCA. Not only did the company print catalogues with their
own Blake illustrations, in which each product was represented by
a line drawing – the work of David Higham's reliable hand – but
in the early 1980s they also produced a small magazine. Although
given free to a mailing list of regular customers, *Cooks' Commentary*
was an absurdly high quality publication. Including illustrations
by Blake and others as well as photography by Phil Sayer, the
magazine ran essays on both contemporary and historical food,
poetry and interviews. The writers included Jane Grigson and Tom
Jaine, with Alan Davidson appearing in an early catalogue. The
discussions in *Cooks' Commentary*, many penned by MacCarthy, helped
define the issues central to Mellor's position as a retailer such as
the importance of tradition, in an interview with basketmaker
Archie Coates, or the debate about mechanisation of tools in the
kitchen. It is easy to see how issues from the kitchen were close
to those Mellor had come up against in his own practice: the
balance between novelty and tradition; whether modernity meant
mechanisation; the loss of independent retailers; the loss of (bio)
diversity, 'There is nothing more dispiriting than searching in a
town centre for a pair of shoes… since the shoes in all the shops
have an extraordinary sameness… Now it seems the same thing
is happening to fruit and vegetables…as with shoes so with
potatoes. All potatoes are the same.' All of Mellor and MacCarthy's
work in retail was surrounded by a personality and humour that
few other retailers matched. Consider the following discussion
on Gingerbread Men to be found in the shop's catalogue, 'The
Gingerbread Man remains an archetypal figure. It is strange to
relate that we sell men much more than women. Not a feminist
issue: just that men are biscuit-shaped.'

Mellor had become a central figure within the British design
fraternity. During the eighties he spent much time in positions of
authority within various important institutions. He was chairman
of a 1983 Design Council committee of inquiry, chairman of the

Crafts Council between 1982 and 1984 and Trustee of the Victoria & Albert Museum between 1983 and 1988. Such appointments brought Mellor close to his desire for lasting positive impact in the public landscape, however they also reignited his dislike of 'design by committee' where Machiavellian diplomacy and politics were required to get one's way. Mellor was too honest and straight-talking to survive in such climates. With the success of the retail business Mellor expanded to more shops in London (Covent Garden and Shad Thames) and one in Manchester. The development in Shad Thames in 1990 was part of a regeneration programme that included the Design Museum and Terence Conran's retail business in creating a new focus for modern design in London. Mellor commissioned Michael Hopkins & Partners to create a purpose-built building on the south bank of the Thames. There was a fanfare of positive press; the financial climate, however, and the underperforming regeneration of Shad Thames as a whole, ultimately led Mellor to withdraw from the site and re-think his strategy.

The demand for Mellor's cutlery designs was still growing and he decided to expand his manufacturing capacity. Looking on the outskirts of Sheffield, he found a pair of abandoned Edwardian gasometers in the Peak District National Park at Hathersage. Mellor, inspired by his European travels, was driven by a desire to prove industrial buildings could be functional and beautiful, in the same way as he thought work should be pleasurable. Approaching British Gas to purchase the site, Mellor bought the land and buildings on conditions laid down by the Peak Park Planning Board. Michael Hopkins & Partners were commissioned again and a gasometer was turned into an open-plan factory space in a sympathetic architectural tour de force. Other buildings on the same site were transformed into offices, a shop and living space for the family. Acclaim followed its opening – and the public took the building to its heart when they voted for it to win the BBC Design Award for the Environment in 1990. Mellor himself said, 'It seems to be a building that everybody likes… the woman in the Post Office

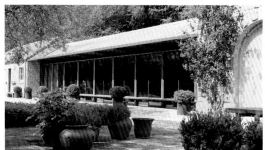

The David Mellor Design Museum and café opposite
the Round Building in Hathersage, designed by Sir
Michael Hopkins & Partners, built 2006.

thinks it's lovely', a comment, which, although glib, expresses his happiness at the local support his presence in Hathersage enjoyed.[15] The Round Building was heralded as a shining example of balance between architectural integrity and the practicalities of a working factory. The building expressed Mellor's lifelong principle that pleasure and good design should exist in a working environment, not just at home. It also concluded Mellor's foray into daunting renovation projects. In 2006 a small museum and café joined the factory, the office buildings and the Mellors' residence on this site.

New cutlery designs were launched regularly throughout the eighties and nineties. The late nineties saw some of Mellor's most arresting designs. A triumph of innovation, the City design required new manufacturing techniques, which he developed alongside the Cutlery Allied Trades Research Association (CATRA). The sculptural nature of the design meant that three pieces of stainless steel had to be welded together, for which a new machine needed to be designed, a usual Mellor practice. City was innovative for its use of three dimensions, the handles of each piece shaped to fit the palm like no other design before it. One of his most radical in terms of design was Minimal. It was the ultimate in what Mellor referred to as 'Minimal de luxe'; the striking simplicity disguises its sophisticated detailing. Awarded a CBE in 2001, Mellor, now in his seventies, began taking a back seat in the day-to-day running of his business and his son, Corin, (also a talented designer) took over many of his responsibilities. Moving into the custody of the next generation, Mellor's ideals and ambitions became a true family business. He died on May 7, 2009, aged 78 and was buried on a hill overlooking Hathersage, near the city from which he never strayed too far.

Ultimately Mellor's career was filled with designs and their prizes; his output varied in type but was constant in quality. His beliefs drove him to find beauty in a bus shelter just as in a silver spoon, but his approach was always pragmatic and altruistic in a way that perhaps few designers are. Mellor's modernism, although forged in the 'white hot technical revolution' of the RCA during the

fifties was modest and unpretentious. Beauty and honesty may be inconstant companions, in life and in design, but in the work of David Mellor there was always ample room for both.

1. Hugh Pearman, 'Set the Table', *Sunday Times*, August 20, 1995.
2. Robin Darwin quoted by, Christopher Frayling, Obituary of Richard Guyatt, *The Guardian*, Saturday 27 October, 2007.
3. Graham Hughes, *Modern Silver Throughout the World*, 1967, p.57.
4. Lucas Hollweg, 'At Home: Genius of the knife, fork and spoon', *The Telegraph*, 8 February, 1997.
5. *Sunday Times*, May 1963, *Architects' Journal*, July 1963 and *Watchmaker, Jewellery and Silversmith*, January 1963.
6. Michael Hatfield, 'Cutlers Clash', *Sheffield Telegraph*, January 1965.
7. Design Centre Awards, Architect and Building News c.1965.
8. Diana Pollock, 'Man of Metal', *The Guardian*, 11 October, 1972.
9. M Rollason, *The Observer*, 27 February 1966, and Anne Scott-James, *Daily Mail* 1966.
10. Lucas Hollweg, 'At Home: Genius of the knife, fork and spoon', *The Telegraph*, 8 February, 1997.
11. *Portsmouth Evening News*, 10 February, 1966.
12. Diana Pollock, 'Man of Metal', *The Guardian*, 11 October, 1972.
13. Mellor's first press release for the shop at Sloane Square.
14. Emily Green, 'Pride and Thrift Sharpen Up', *The Independent*, 8 June, 1991.
15. Suzanne Cassidy, 'Friendly Factory', *Chicago Tribune*, Sunday September 16, 1990.

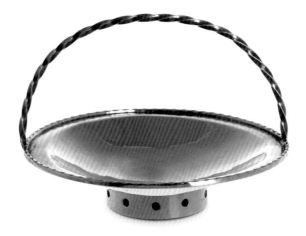

Sweet dish, the first piece of metalwork made by 11 year-old Mellor at Sheffield's Junior Art Department.

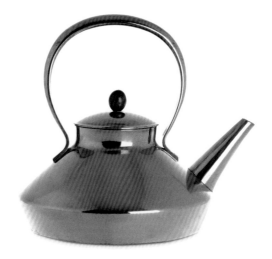

Kettle, designed at the RCA, gilding metal and laburnum. Mellor picked up the laburnum while at a farming camp in Lincolnshire then waited to find a use for it in one of his designs.

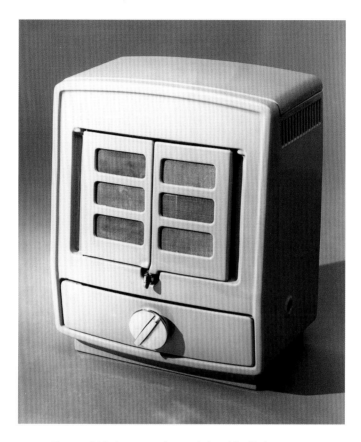

Queen solid fuel convector heater designed for Grahamston Ironfounders of Falkirk, 1958. Winner of a Design Centre Award the following year, products like these show the variety of Mellor's work so soon after graduating from the RCA.

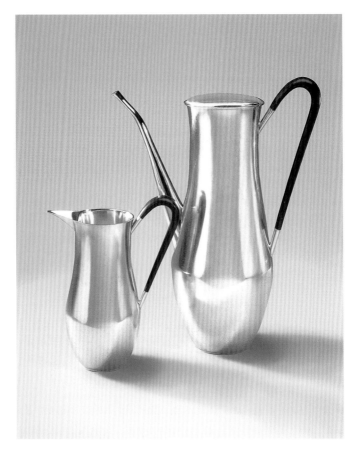

Silver coffee pot and milk jug, both with rosewood handles, made
in the year the designer started at the Royal College of Art.

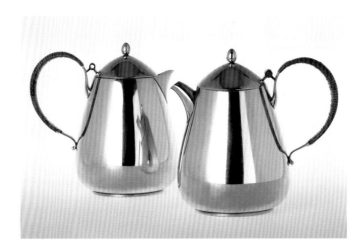

Silver tea pot and water pot, both with handles bound in cane c.1952.

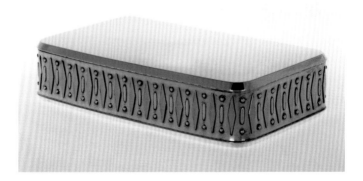

Silver cigarette box with gold lozenge decoration, 1956. An example of a rare foray into surface embellishment, Mellor's one-off pieces frequently show a more varied decorative approach than his mass-produced work.

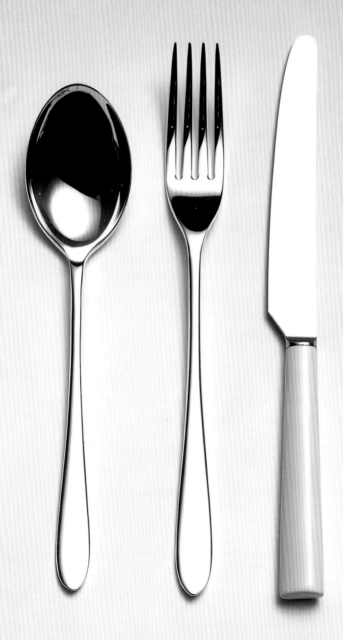

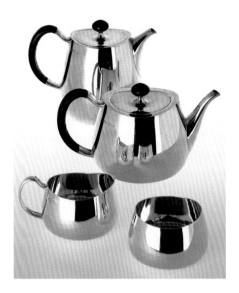

Pride tea set with black leather handles, made by Walker & Hall, 1958.

Pride silver plate cutlery (above and opposite), 1953. A design that has become synonymous with Mellor, selected for the first series of Design Centre Awards in 1957, and still in production today.

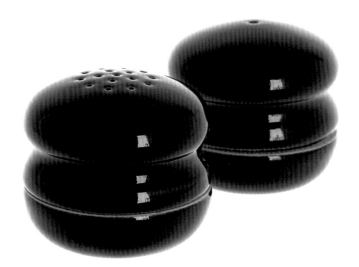

Ceramic salt and pepper pots designed for J R Bramah, 1968. Mellor began designing stainless steel tableware for the Sheffield firm J R Bramah in the 1960s.

Silver sugar castor (opposite) with chased decoration, 1955. After leaving the Royal College of Art in 1954, with a silver medal, Mellor set up his first workshop in Eyre Street, Sheffield making one-off pieces of silver for private and public commissions.

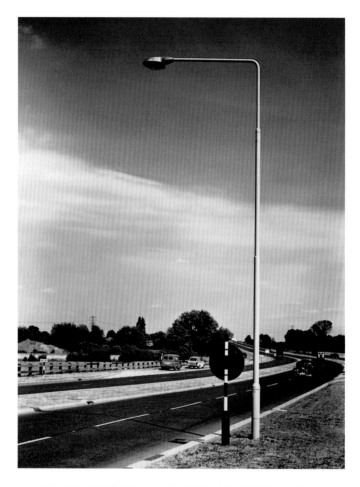

Lighting columns for Abacus, 1955. While at the British School in
Rome Mellor regularly walked past the 1930s steel lighting columns
in the Borghese Gardens, they prompted him to develop this design
to modernise British roads.

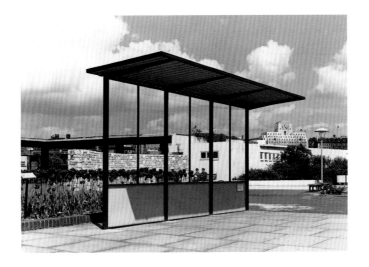

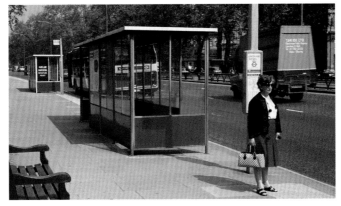

Bus shelters for Abacus, 1959. Mellor had a very fruitful working relationship with Abacus, it gave the designer a rewarding sense of broad influence on the British landscape.

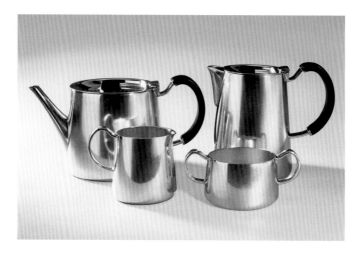

Fanfare tea set for Walker & Hall, 1961.

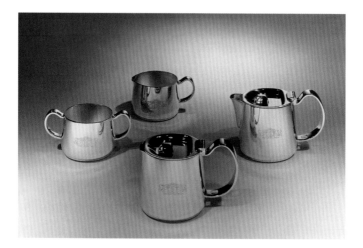

Pullman Car tea set for Walker & Hall, 1960. Silver plate engraved with the lion and unicorn, used for afternoon tea on British Rail Pullman Cars.

Iced water jug (opposite) designed for cruise ship *SS Canberra*, silver plate, 1960.

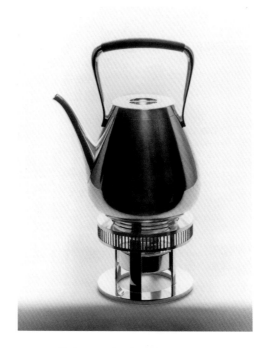

Embassy tea kettle and heater, silver.

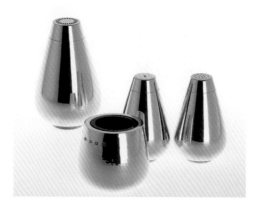

Embassy silver condiment set and sugar shaker.

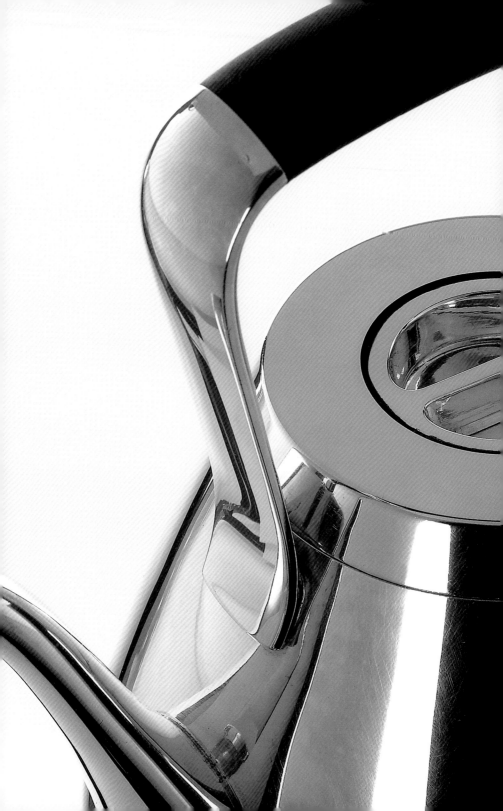

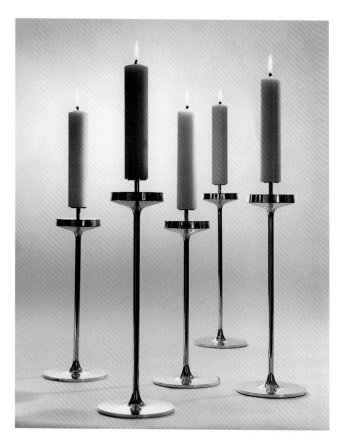

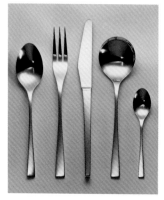

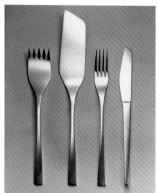

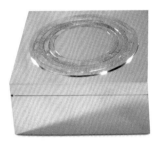

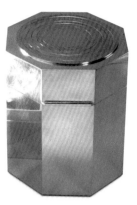

Square and hexagonal silver boxes with gilt lids, made for the Worshipful Company of Goldsmiths, 1966.

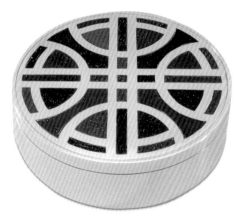

Silver powder bowl made by Mellor with blue enamel lid by Cameron Maxfield, 1966.

Embassy candlesticks, silver cutlery, fish servers and eaters (opposite). The first new embassy to be equipped with the *Embassy* design was Warsaw.

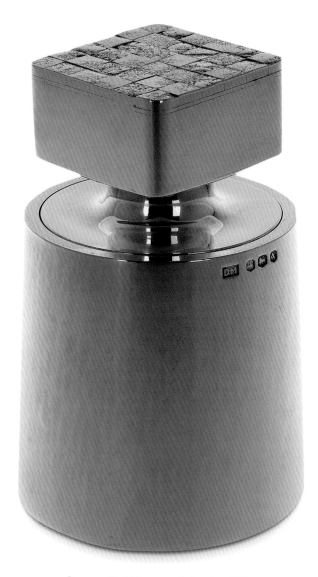

Pepper mill with hammered silver top, 1965.

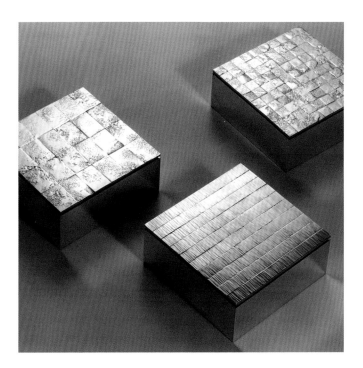

Series of silver boxes with textured gilt lids, 1966. The Worshipful Company of Goldsmiths, in particular their art director Graham Hughes, was greatly supportive of the silversmithing resurgence during the 1960s in Britain.

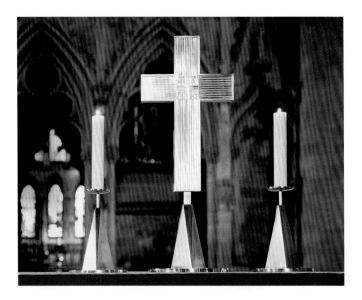

Nave altar cross and candlesticks (top) commissioned
for Southwell Minster, 1963. Brass candlesticks (above)
for St Silas's Church, Sheffield, 1961.

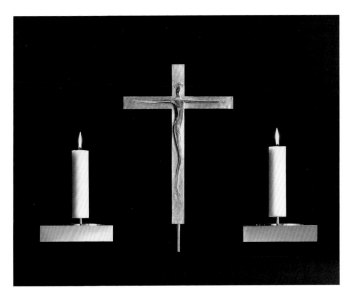

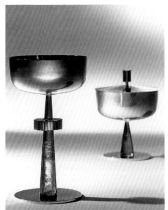
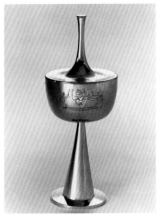

Silver crucifix and candlesticks (top) commissioned for the Roman
Catholic Metropolitan Cathedral, Liverpool, 1969. Communion silver
(above left) made for the chapel of the University College of St Martin,
Lancaster, 1966. Engraved silver cup (above right) designed and made
by Mellor for the Worshipful Company of Coachmakers, 1963.

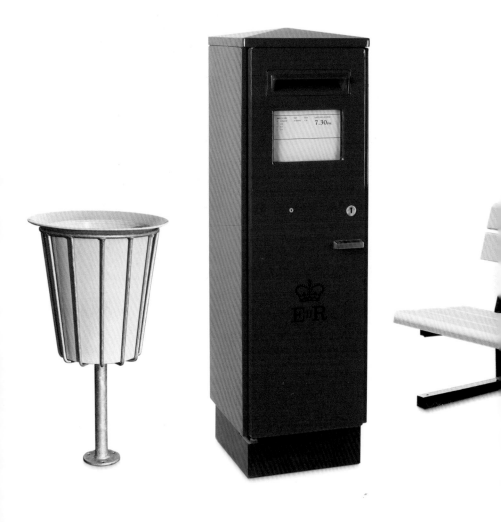

From left to right, Galvanised steel litter bin for Abacus, 1957. Square-profile pillar box commissioned by the Post Office, 1966; the controversial modernisation of the postbox. Fiona McCarthy, Mellor's wife, defended the design in the Guardian, 'It will no doubt make a lot of enemies: enemies of progress, imbibers of nostalgia; men who shudder at the Council of Industrial

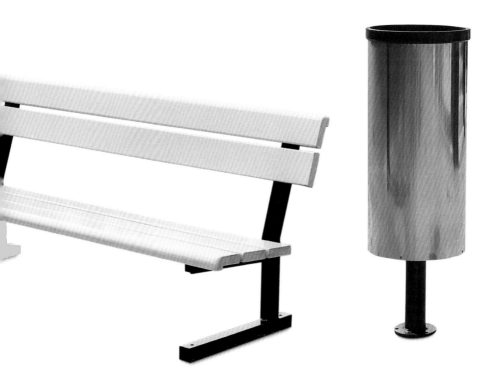

Design. Perhaps the P[ost] M[aster] G[eneral] really wants a showdown. It is, almost certainly, what he is going to get. Perhaps he is simply thinking of his postmen who have asked for a practical pillar box for years.' Outdoor seating for public spaces for Abacus, 1962. Abacus litter bin in stainless steel with hard rubber moulded rim, 1965.

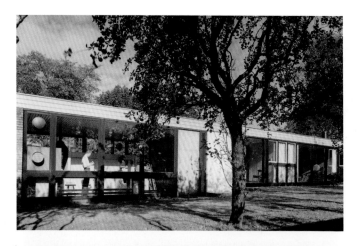

Mellor's purpose-built studio-workshop, I Park Lane, Sheffield. A contemporary journalist wrote it 'combines dramatic simplicity of style and furnishing with enough comfort for the reluctant bachelor'. Mellor's own design for a bronze fireplace, built into the structure of his studio workshop.

Bronze fountain (opposite) commissioned by the University Botanic Garden in Cambridge, 1968-69. A series of height-adjustable great bronze discs cast by the Morris Singer Foundry, Basingstoke. The overall impression of the fountain, although on a larger scale, echoes Mellor's tableware, notably the *Embassy* candlesticks designed a few years earlier.

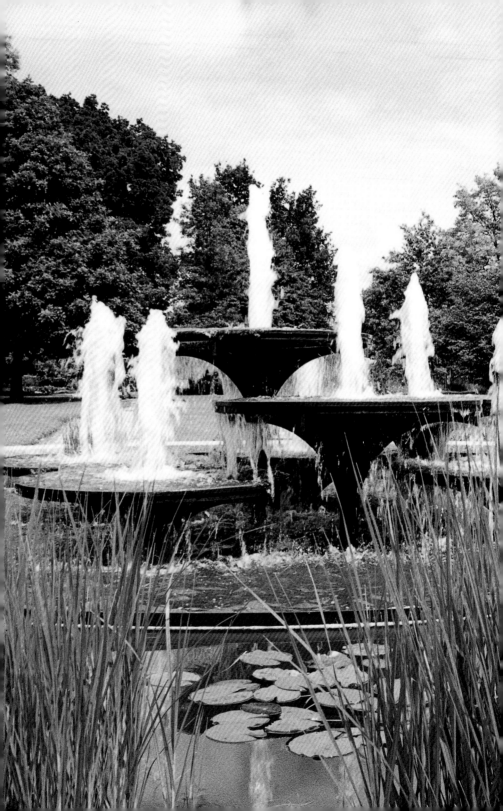

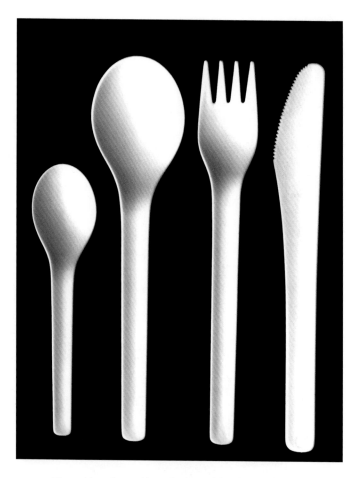

Disposable cutlery, white polystyrene. Manufactured by
Cross Paperware from 1969. Forever interested in modern
technology and materials, Mellor wanted to make disposable
cutlery that was still functional and attractive, some users
liked them so much they washed and re-used them.

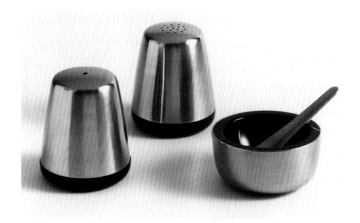

Stainless steel salt and pepper and mustard pots for J R Bramah, 1968.

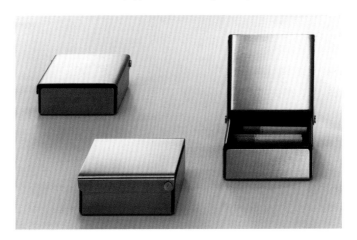

Stainless steel cigarette boxes for J R Bramah,
with black acetal resin moulded lining, 1968.

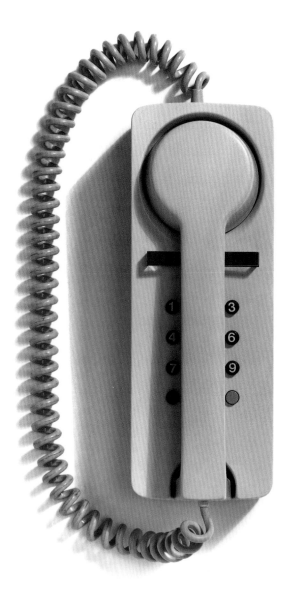

Advanced push-button telephone developed for Standard
Telephones & Cables, 1968, once again showing the
designer's conviction that good design was not just for the
home but also for the workplace.

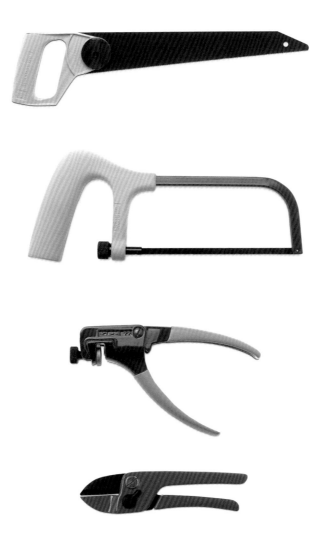

From top, *Eclipse* general purpose saw, *Eclipse* junior saw, *Eclipse* saw tooth setter designed for James Neill, Sheffield, early 1970s. Garden secateurs, with plastic coated steel handles, designed for John Guy, Sheffield, 1972.

David Mellor, Ironmonger, Sloane Square, opened in 1969. Like all of Mellor's buildings and interiors, much of the work was done by the designer and his employees. Furniture designer and friend, Ron Carter, collaborated on the interior design of the shop, he remembered the experience, 'Mixing concrete for foundations on a bitterly cold Sunday was a typical situation which I learned to expect.'

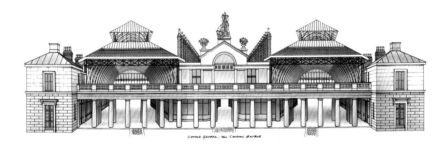

Covent Garden mug, illustrated by David Gentleman. The artwork
was commissioned for the James Street shop in Covent Garden.
Gentleman was paid in cutlery and saucepans.

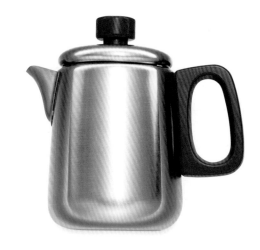

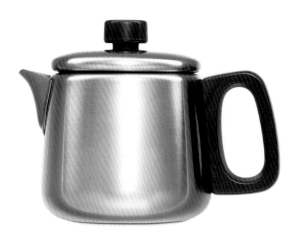

Au Pair coffee and tea pots designed for J R Bramah, stainless steel with coloured acetal resin knobs and handles, 1969.

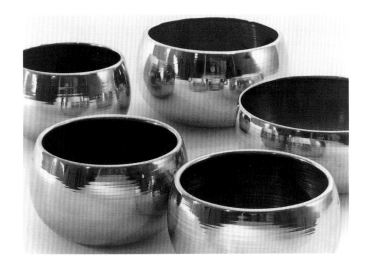

Deep and shallow brass bowls, 1970s, hand spun by
apprentice Russell Rimes in Mellor's Sheffield workshop.

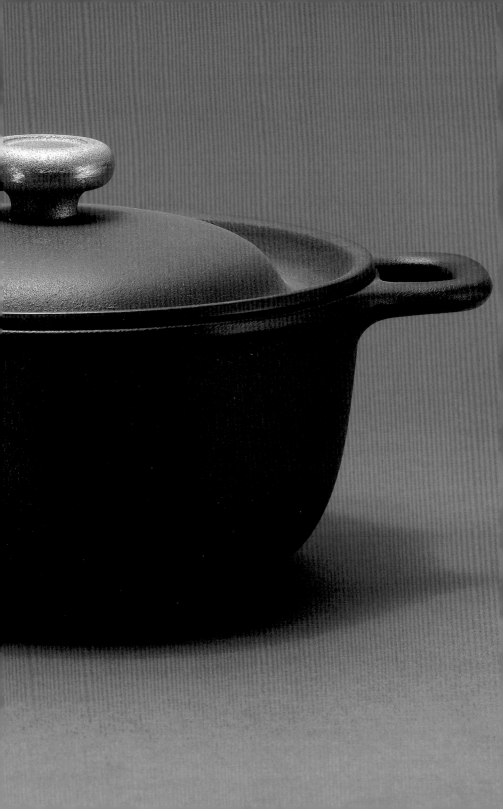

Aluminium stewpots and saucepans with teak knobs and handles (above), and prototype cast-iron casserole with aluminium knob (opposite). The opening of the shop in Sloane Square prompted the designer to consider gaps in the market, one such resulted in Mellor's own range of saucepans and stewpots.

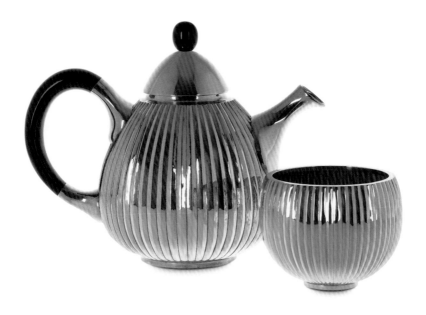

Faceted silver tea set with buffalo horn handle and knob, 1974. Although diversifying into mass production and retailing, Mellor continued to design handmade silver pieces. Silver pepper mill with faceted top (below), 1973.

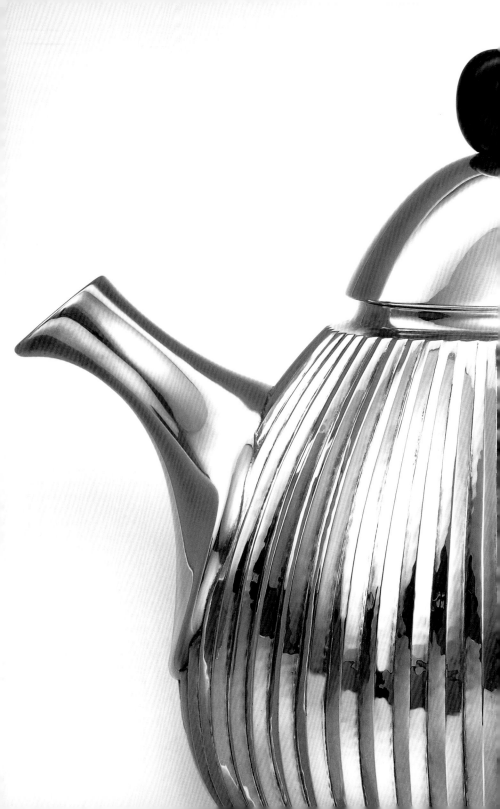

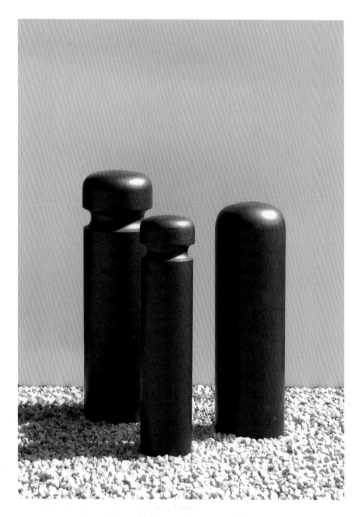

Cast-iron bollards for Abacus, 1974.

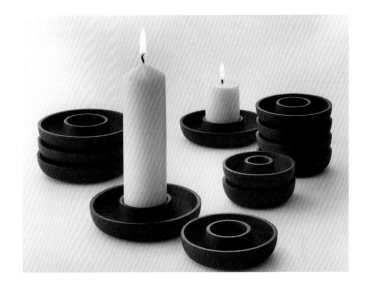

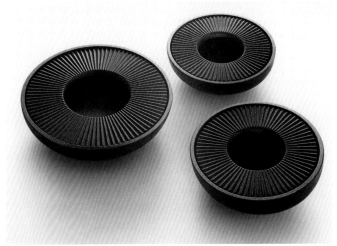

Cast-iron candleholders (top) and bowls (above). The bowls
with ridged inserts for use as candleholders or ashtrays

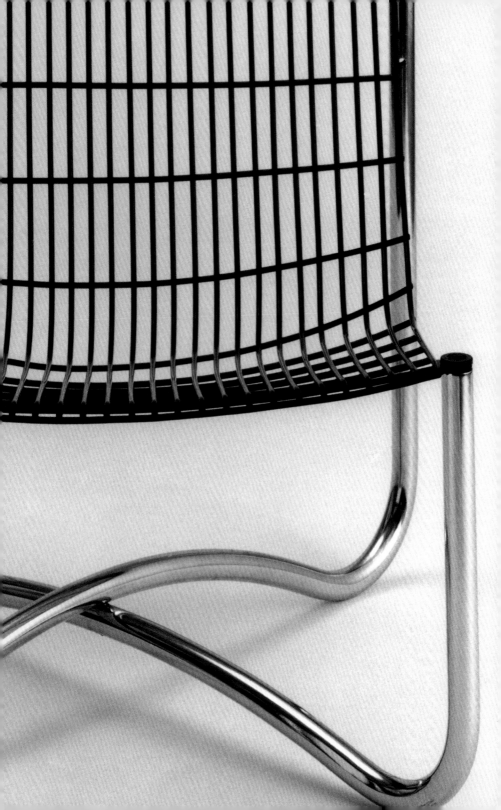

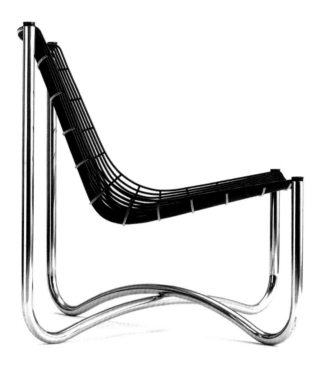

Chair for Abacus *700 outdoor seating system* exemplifying the
hi-tech aesthetic of the 1970s, winner of a Design Council
Award, 1974. The design was very flexible, indoors or out, with
or without arms, collapsible and available in a range of finishes.

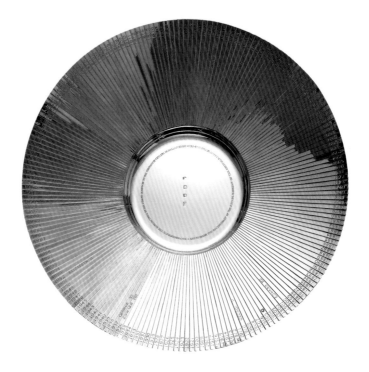

Silver bowl commissioned by the Company of Cutlers,
1973, celebrating the 200th anniversary of the
Sheffield Assay Office. The bowl is divided into 201
segments, each one engraved with a year date, and, on
coronation years, the name of the new monarch.

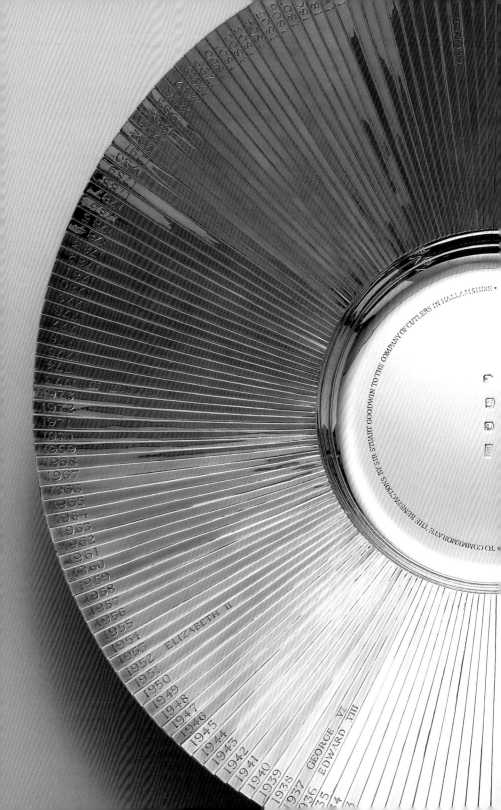

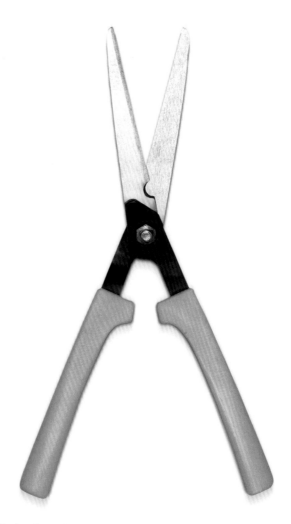

Garden shears, *Model 501*. Hardened steel blades and polypropylene handles moulded onto a wooden core. Designed in 1970 for Burgon & Ball, they were a stylistic departure from the sheep shears that the traditional firm were well known for.

Child's set introduced in 1978. It was a stylistic development of the *Java* design from the previous year and brought good quality cutlery to children's meal times.

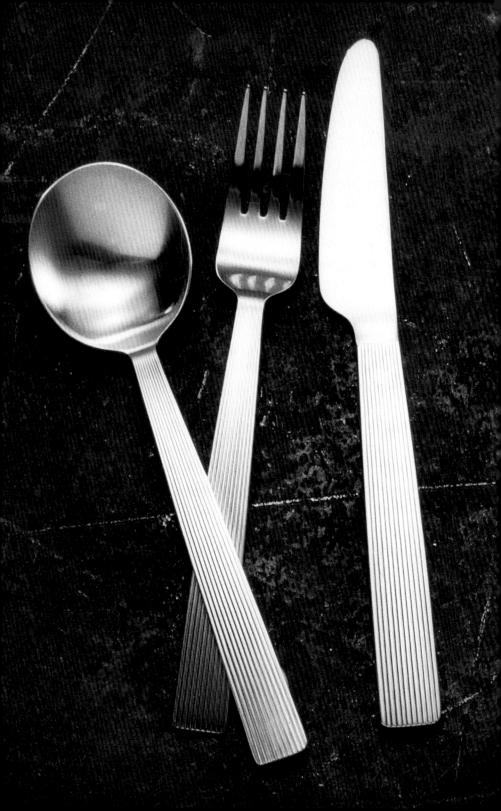

Cutlery for disabled people, designed in 1986 as part of the Helen Hamlyn Foundation's campaign to improve living standards for elderly people, demonstrating Mellor's belief that good design is for all.

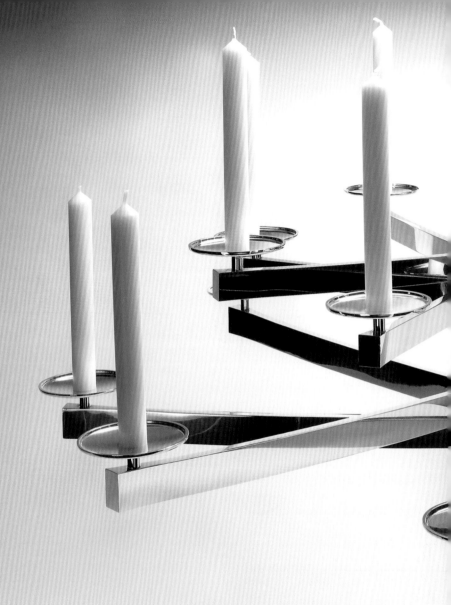

16-light silver candelabrum, 90cm across. Commissioned
by the Worshipful Company of Goldsmiths, 1963.

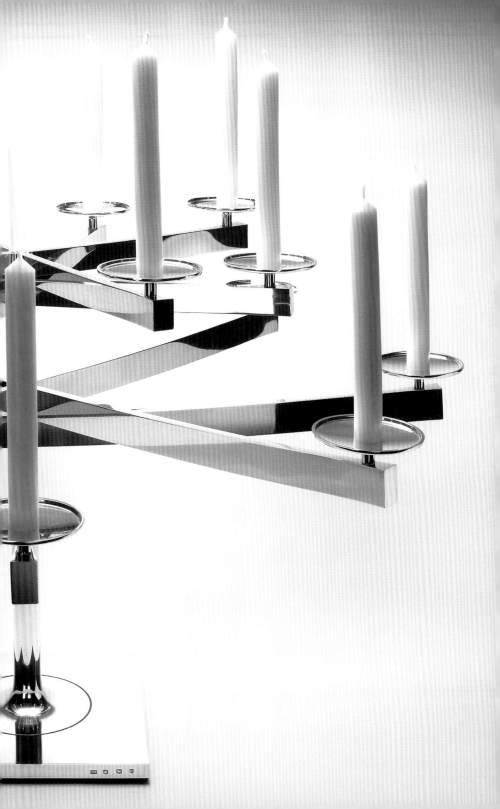

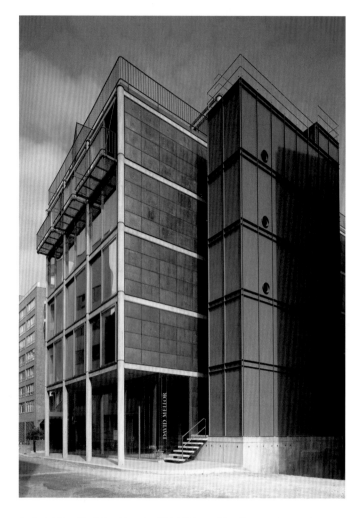

Butler's Wharf building (above) which Mellor sold to Terence Conran; it became his headquarters. Kitchen knives (right) in stainless steel using the same construction techniques as *City* and stemming from a similar moulded and sculptural aesthetic. 1999.

Page 82-83: First row left to right: *Café* 1982 , *Chinese Green* 1977, *Classic* 1984. Second row left to right: *Provencal*, 1973, *City* 1998 , *London* 2004. Third row left to right: *Paris* 1993, *Odeon* 1986, *Minimal* 2002.